THE ART OF DRAWING

MANGA™

ACTION &MOVEMENT

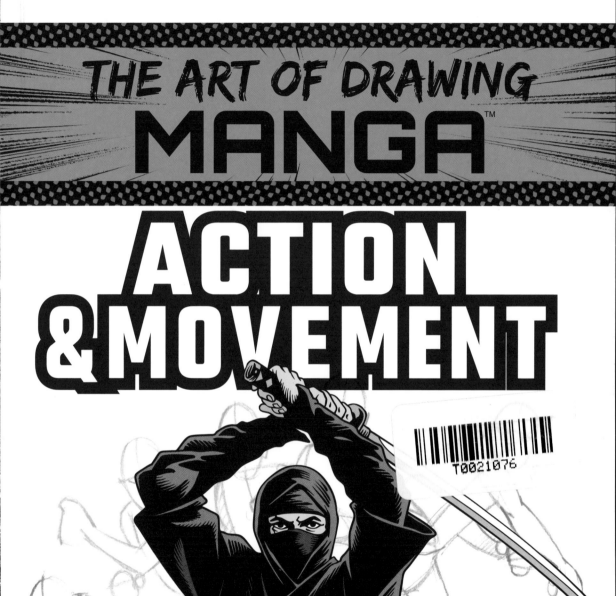

T0021076

Author: Max Marlborough has been passionate about graphic design and manga from an early age and works as a freelance author, illustrator and designer of art guides for readers of all ages.

Artist: David Antram studied at Eastbourne College of Art and then worked in advertising for fifteen years before becoming a full-time artist. He has since illustrated many popular information books for children and young adults, including more than 60 titles in the bestselling *You Wouldn't Want To Be* series.

Additional artwork: Mark Bergin, David Stewart, Peter Kempton, Iko Sakamoto, ayelet-keshet/ Shutterstock.com, Danilo Sanino/Shutterstock. com, Orionwalker/Shutterstock.com, ledokolua/ Shutterstock.com, Dolimac/Shutterstock.com

Published in Great Britain in MMXX by Book House, an imprint of
The Salariya Book Company Ltd
25 Marlborough Place, Brighton BN1 1UB
www.salariya.com

PB ISBN: 978-1-912904-82-2

SCRIBO BOOK HOUSE SCRIBBLERS

© The Salariya Book Company Ltd MMXX
All rights reserved. No part of this publication may be reproduced, stored in or introduced into a retrieval system or transmitted in any form, or by any means (electronic, mechanical, photocopying, recording or otherwise) without the written permission of the publisher. Any person who does any unauthorised act in relation to this publication may be liable to criminal prosecution and civil claims for damages.

1 3 5 7 9 8 6 4 2

A CIP catalogue record for this book is available from the British Library.

Printed and bound in China.

This book is sold subject to the conditions that it shall not, by way of trade or otherwise, be lent, resold, hired out, or otherwise circulated without the publisher's prior consent in any form or binding or cover other than that in which it is published and without similar condition being imposed on the subsequent purchaser.

Visit
www.salariya.com
for our online catalogue and
free fun stuff.

PAPER FROM

SUSTAINABLE
FORESTS

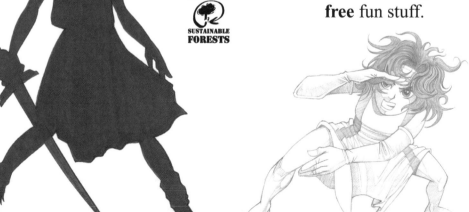

THE ART OF DRAWING
MANGA™

ACTION & MOVEMENT

BOOK HOUSE
a SALARIYA imprint

MAY MARI BOROUGH DAVID ANTRAM

Contents

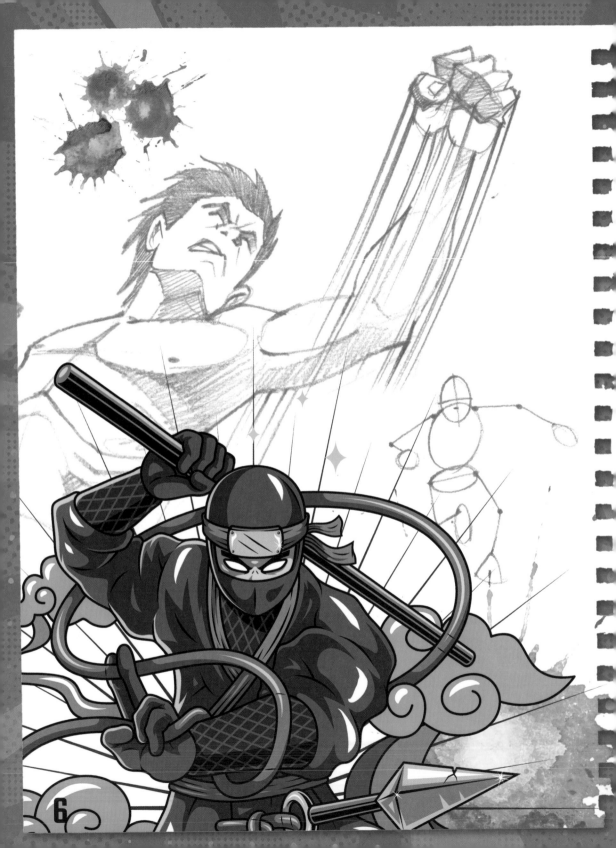

Making a start

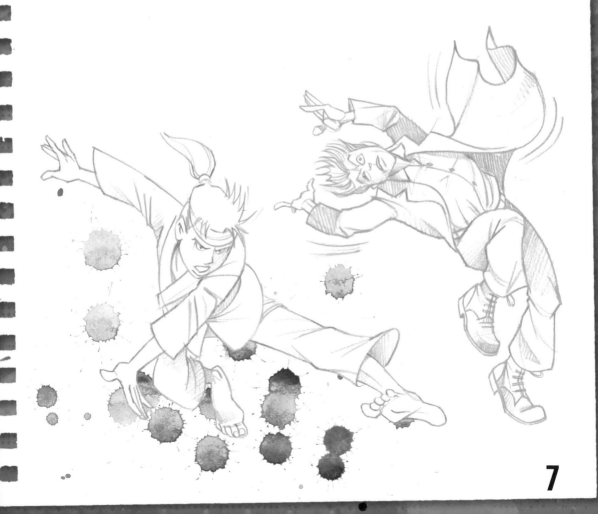

Introduction

The key to drawing well is learning to look carefully. Study your subject until you know it really well. Keep a sketchbook with you and draw whenever you get the chance. Even doodling is good – it helps to make your drawing more confident. You'll soon develop your own style of drawing, but this book will help you to find your way.

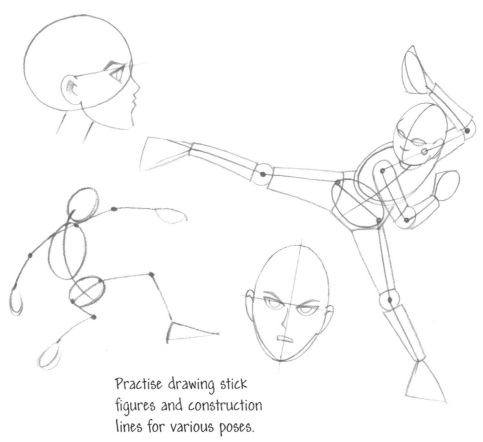

Practise drawing stick figures and construction lines for various poses.

Stick figures

Drawing stick figures with construction
lines will help to create character poses.
The body is divided into ovals and lines.
Use ovals for the head, body, hips,
hands and feet. Use lines for the legs
and arms, marking in joints with dots.

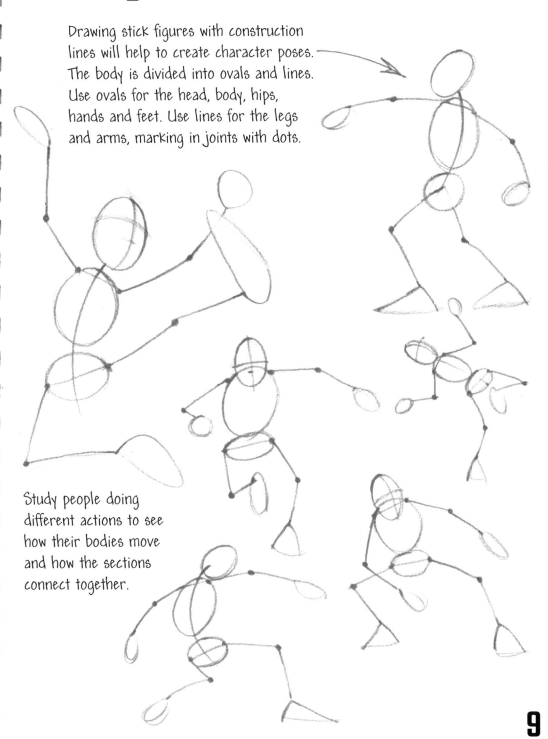

Study people doing
different actions to see
how their bodies move
and how the sections
connect together.

Introduction (2)

It's important to experiment with different shapes and movements so that you gain experience.

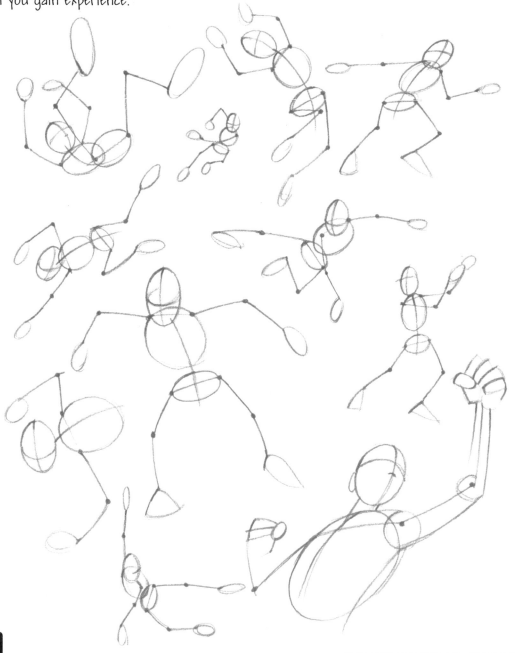

Stick figures

Here we can see how the simple stick figures are fleshed out to create the characters' forms.

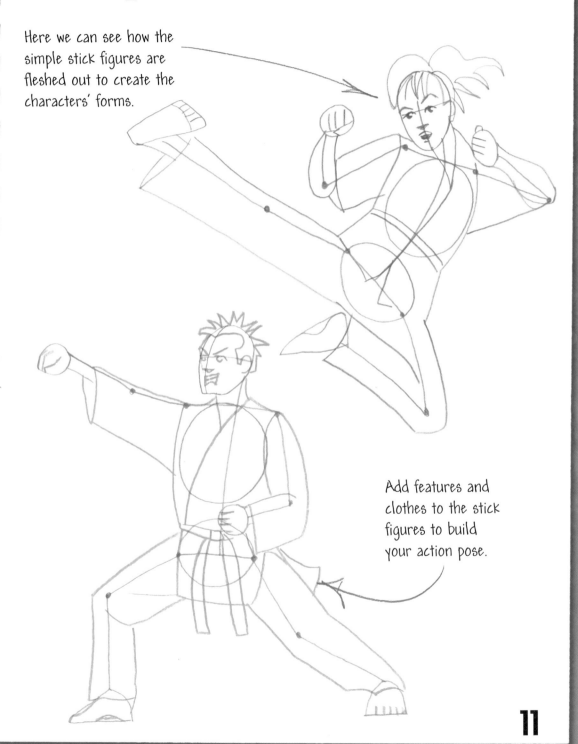

Add features and clothes to the stick figures to build your action pose.

Perspective

Perspective is a way of drawing objects so that they look as though they have three dimensions. Note how the part that is closest to you looks larger, and the part furthest away from you looks smaller. That's just how things look in real life.

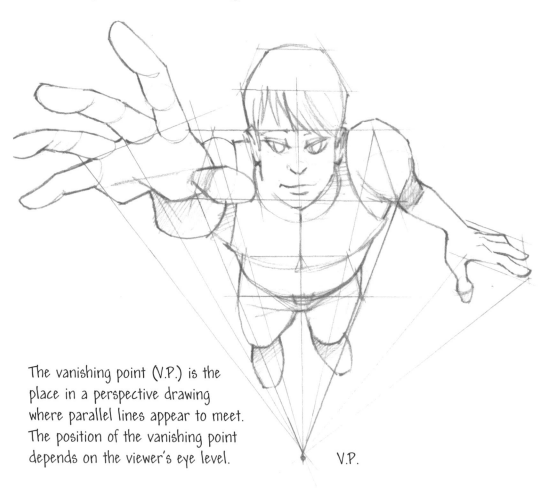

The vanishing point (V.P.) is the place in a perspective drawing where parallel lines appear to meet. The position of the vanishing point depends on the viewer's eye level.

V.P.

Two-point perspective drawing

Two-point perspective uses two vanishing points: one for lines running along the length of the subject, and one on the opposite side for lines running across the width of the subject.

Low eye level (view from below)

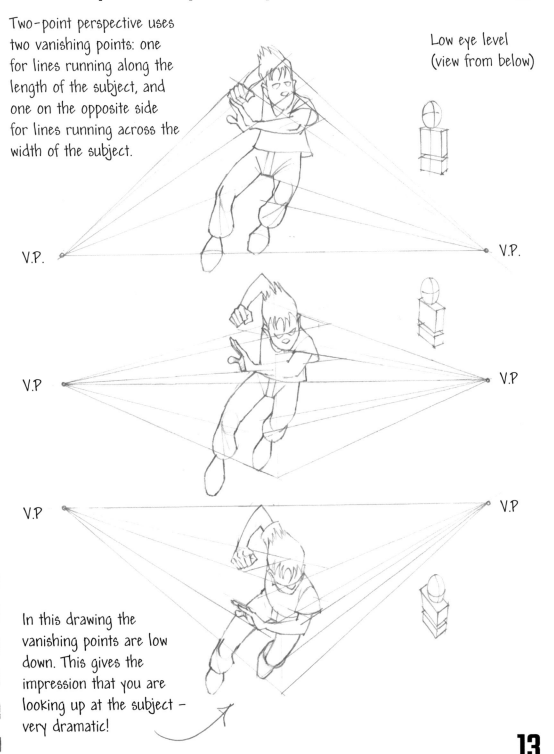

V.P. V.P.

V.P V.P

V.P V.P

In this drawing the vanishing points are low down. This gives the impression that you are looking up at the subject – very dramatic!

Materials

Pencils

Try out different grades of pencils. Hard pencils make fine grey lines and soft pencils make softer, darker marks.

Erasers

are useful for cleaning up drawings and removing construction lines.

Paper

Bristol paper is good for crayons, pastels and felt-tip pens. Watercolour paper is thicker; it is the best choice for water-based paints or inks.

Remember, the best equipment and materials will not necessarily make the best drawing – only practice will.

Use this sandpaper block if you want to shape your pencil to a really sharp point.

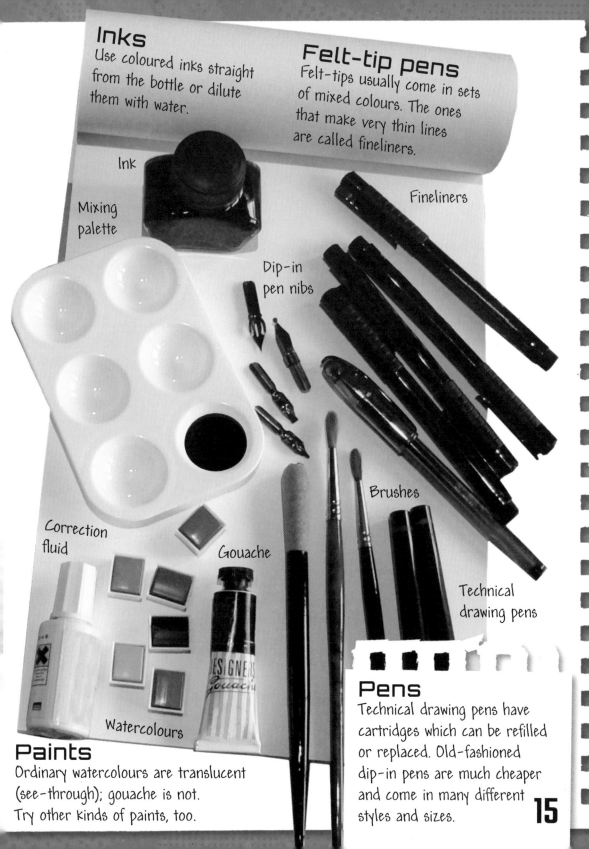

Inks
Use coloured inks straight from the bottle or dilute them with water.

Felt-tip pens
Felt-tips usually come in sets of mixed colours. The ones that make very thin lines are called fineliners.

Ink

Mixing palette

Fineliners

Dip-in pen nibs

Brushes

Correction fluid

Gouache

Technical drawing pens

Watercolours

Paints
Ordinary watercolours are translucent (see-through); gouache is not. Try other kinds of paints, too.

Pens
Technical drawing pens have cartridges which can be refilled or replaced. Old-fashioned dip-in pens are much cheaper and come in many different styles and sizes.

15

Styles

Try different types of drawing papers and materials. Experiment with pens, from felt-tips to ballpoints. They will make interesting marks. What happens if you draw with pen and ink on wet paper?

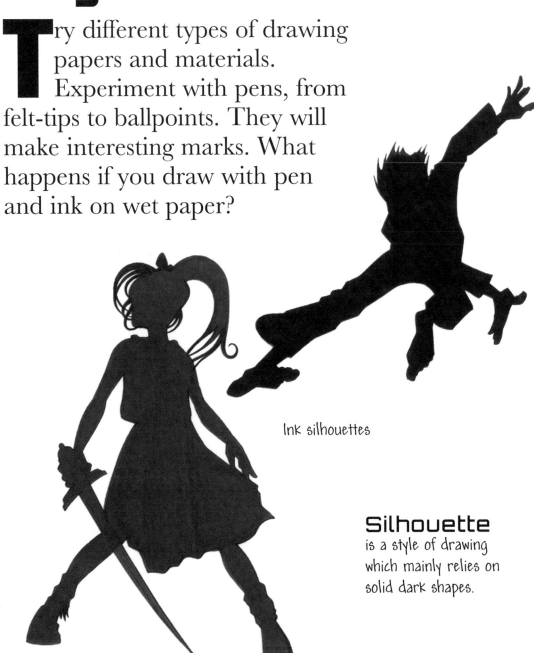

Ink silhouettes

Silhouette
is a style of drawing which mainly relies on solid dark shapes.

Ink

drawings cannot be erased so keep your drawings less rigid. Do not worry about making mistakes as they can be lost in the drawing as it develops.

It can be difficult adding light and shade to a drawing with ink. You can use a technique called cross-hatching (straight lines criss-crossing each other) for the very darkest areas and hatching (straight lines running parallel to each other) for midtones.

If you are not very confident working with ink you may want to sketch your work in pencil first.

Hatching

Cross-hatching

17

Styles continued

Pencil

drawings can include a vast amount of detail and tone. Try experimenting with different grades of pencil to get a range of light and shade effects in your drawing.

Hard pencils are greyer and soft pencils are blacker. Hard pencils are graded from 6H (the hardest) through 5H, 4H, 3H and 2H to H.

Soft pencils are graded from B, 2B, 3B, 4B and 5B up to 6B (the softest). The HB pencil is between H and B.

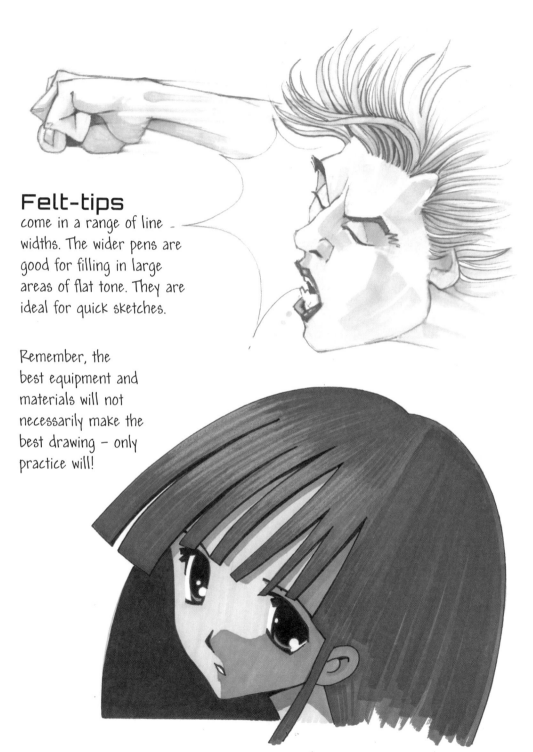

Felt-tips

come in a range of line widths. The wider pens are good for filling in large areas of flat tone. They are ideal for quick sketches.

Remember, the best equipment and materials will not necessarily make the best drawing – only practice will!

19

Inking

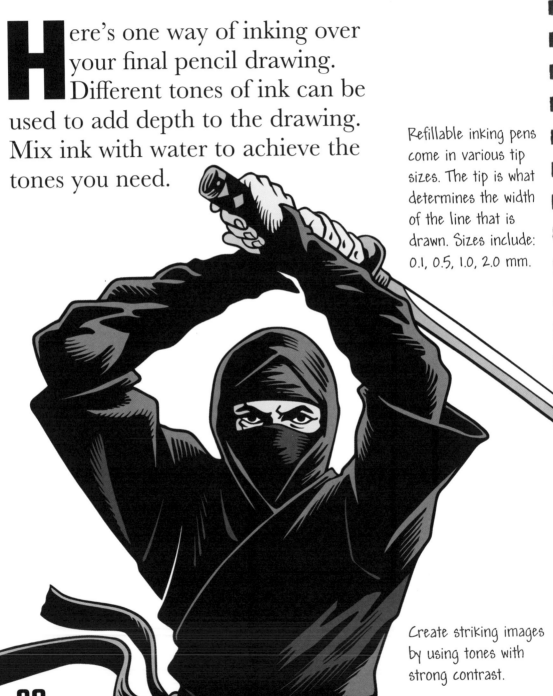

Here's one way of inking over your final pencil drawing. Different tones of ink can be used to add depth to the drawing. Mix ink with water to achieve the tones you need.

Refillable inking pens come in various tip sizes. The tip is what determines the width of the line that is drawn. Sizes include: 0.1, 0.5, 1.0, 2.0 mm.

Create striking images by using tones with strong contrast.

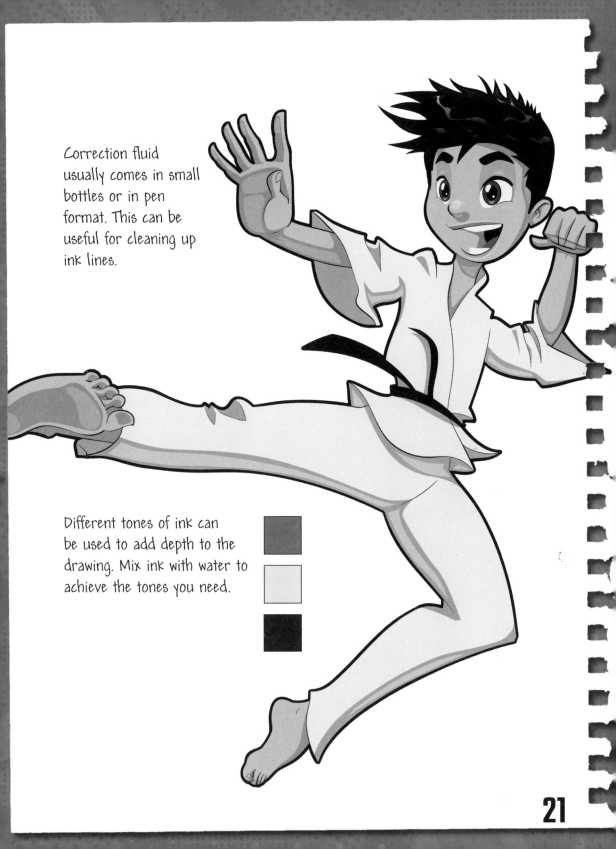

Correction fluid usually comes in small bottles or in pen format. This can be useful for cleaning up ink lines.

Different tones of ink can be used to add depth to the drawing. Mix ink with water to achieve the tones you need.

21

Heads

Manga heads have a distinctive style and shape that you will need to emulate to make your pictures look authentic.

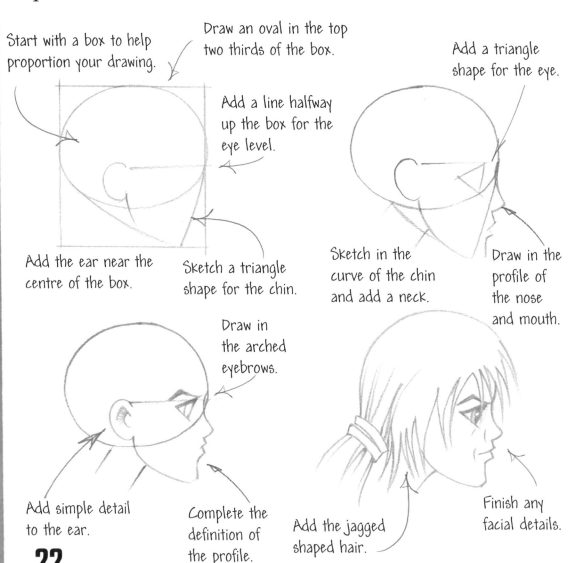

Start with a box to help proportion your drawing.

Draw an oval in the top two thirds of the box.

Add a triangle shape for the eye.

Add a line halfway up the box for the eye level.

Add the ear near the centre of the box.

Sketch a triangle shape for the chin.

Sketch in the curve of the chin and add a neck.

Draw in the profile of the nose and mouth.

Draw in the arched eyebrows.

Add simple detail to the ear.

Complete the definition of the profile.

Add the jagged shaped hair.

Finish any facial details.

Practise drawing heads from different angles and with different facial expressions.

Whichever way the head is turned, the nose and mouth always stay on the centreline.

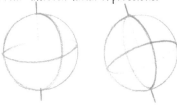 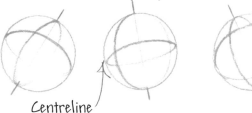

Centreline

Start by drawing a large oval for the face. Then draw two lines dividing the face horizontally and vertically through the centre. Add two small ovals on the horizontal lines for eyes.

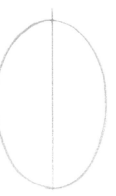 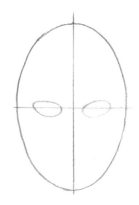

On the vertical line mark in the position of the bottom of the nose and the mouth. Draw the eyebrows. Add ears to the outside oval. Make the chin more angular by drawing a curved line from each ear to the centre of the oval.

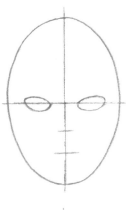 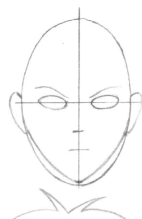

Draw in the oversized shape of the eyes. Add the small nose and mouth. Draw in the hair using jagged lines and add shading to the eyes. Finish by carefully removing the construction lines.

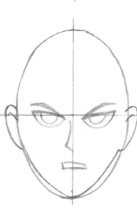 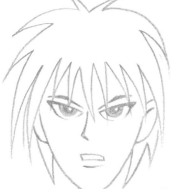

23

Hair

Manga characters can be easily identified by their hair, as it is generally very stylised. When drawing hair you need to think about what your character is doing and how their hair will look whilst doing certain actions.

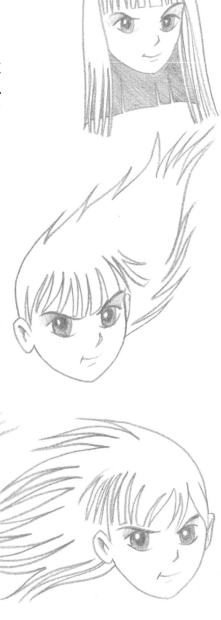

Movement will affect the way hair looks.

Hair is a good way to reflect your character's personality. Why don't you try experimenting with different styles?

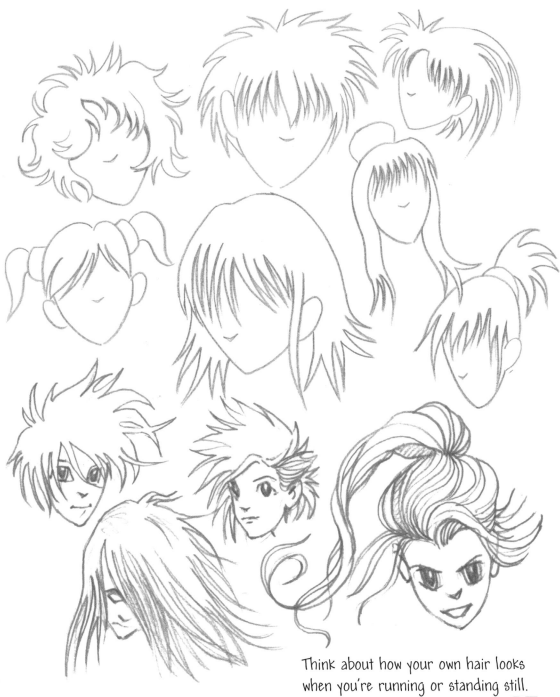

Think about how your own hair looks
when you're running or standing still.

Expressions

Drawing different facial expressions is very important in manga. It's the way to show instantly what your character is thinking or feeling. Practise drawing different facial expressions.

Start by drawing an oval shape. You can make it three dimensional with curved lines going through the centre.

Use these construction lines to add the basic details of the head.

Add the mouth, eyebrows and shape of the nose.

Finish the drawing by adding hair and facial details. This manga character is happy.

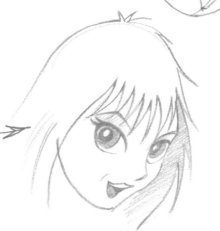

Manga characters have many different facial expressions. Here are a few for you to try.

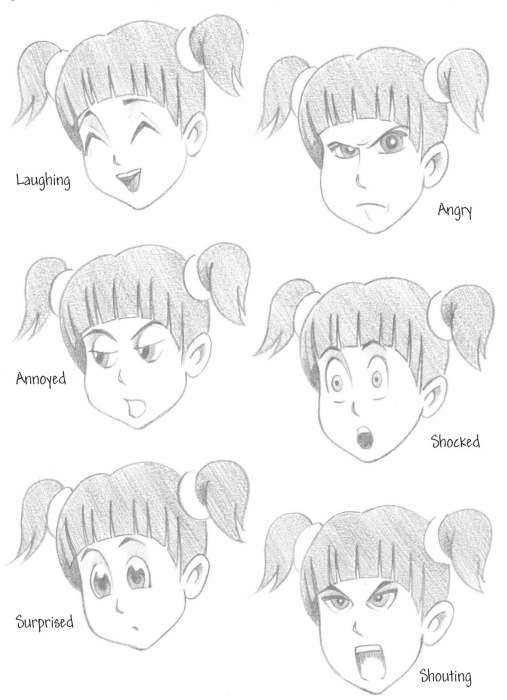

Laughing

Angry

Annoyed

Shocked

Surprised

Shouting

27

Creases and folds

Clothes fall into natural creases and folds when worn. Look at real people to see how fabric drapes and how it falls into creases. This will help you to dress your characters more realistically.

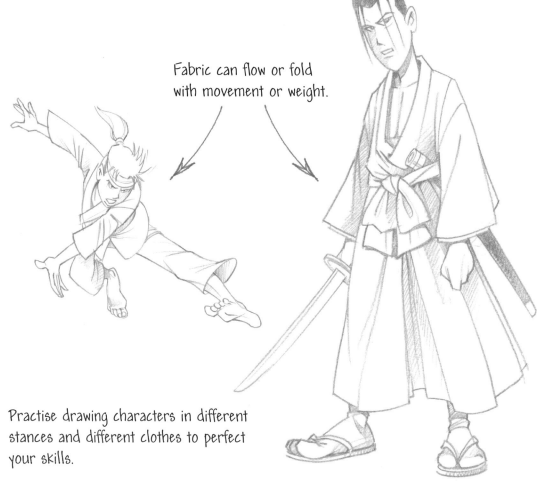

Fabric can flow or fold with movement or weight.

Practise drawing characters in different stances and different clothes to perfect your skills.

The way fabric is drawn can instantly give a sense of movement and action to a pose.

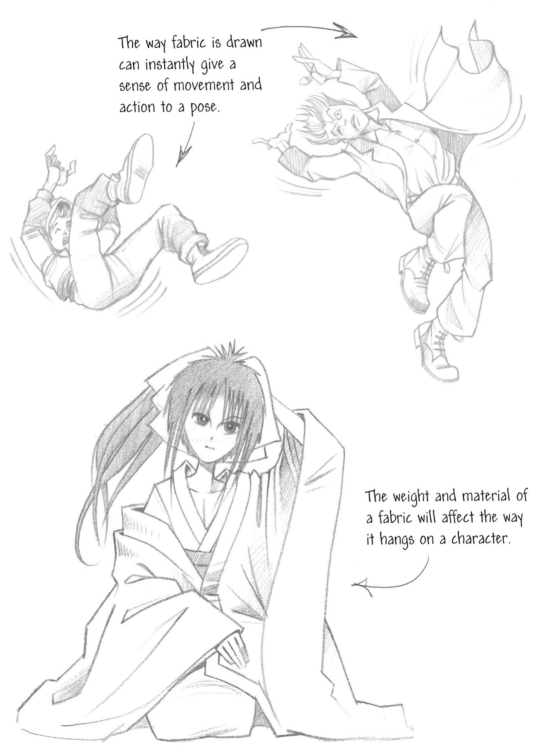

The weight and material of a fabric will affect the way it hangs on a character.

Action poses

Motion and balance are important aspects to consider in your drawing. Use basic construction lines to create a variety of poses. Then build the drawing up from there.

Exaggerate the curve of the centre line to give movement and action to your figure.

Add shading to any areas where light would not reach.

Studying real people to see how their bodies move, whilst performing different actions, will help you create more realistic drawings. You can always test the actions yourself if you're not sure.

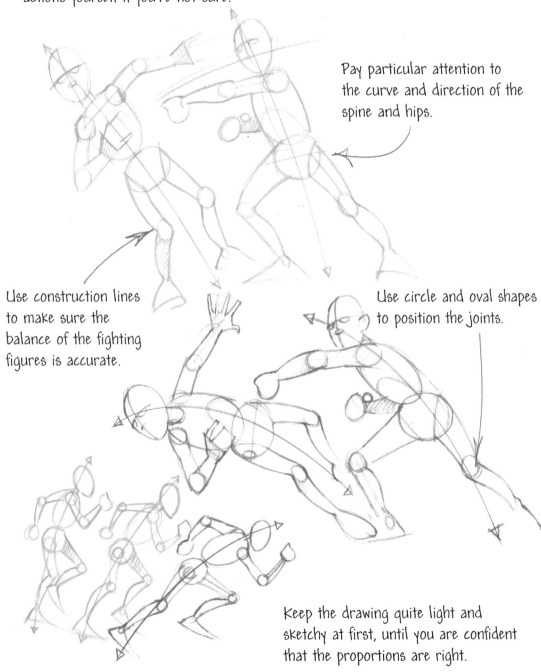

Pay particular attention to the curve and direction of the spine and hips.

Use construction lines to make sure the balance of the fighting figures is accurate.

Use circle and oval shapes to position the joints.

Keep the drawing quite light and sketchy at first, until you are confident that the proportions are right.

Adding movement

Changing the style and position of the movement lines can create many different types of fighting movements.

Start by sketching these simple shapes.

Head

Body

Draw an oval for the head and body and smaller ovals for hands.

Sketch in the arms using straight lines. Add dots to indicate the joints.

Using your construction lines as a guide, sketch simple tube shapes for the arms.

Sketch in the positions of the facial features and hair.

Complete the facial features.

Add circles for the joints.

Add shading and tone to create muscle definition.

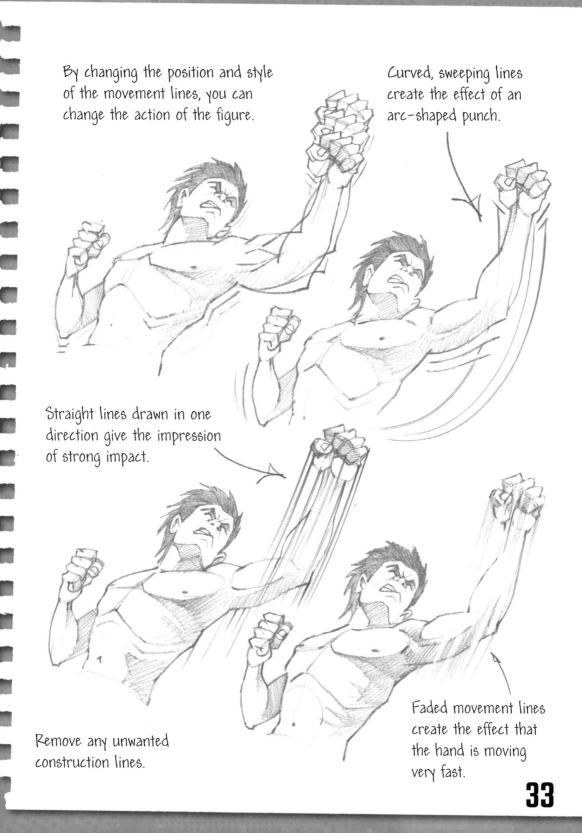

By changing the position and style of the movement lines, you can change the action of the figure.

Curved, sweeping lines create the effect of an arc-shaped punch.

Straight lines drawn in one direction give the impression of strong impact.

Remove any unwanted construction lines.

Faded movement lines create the effect that the hand is moving very fast.

33

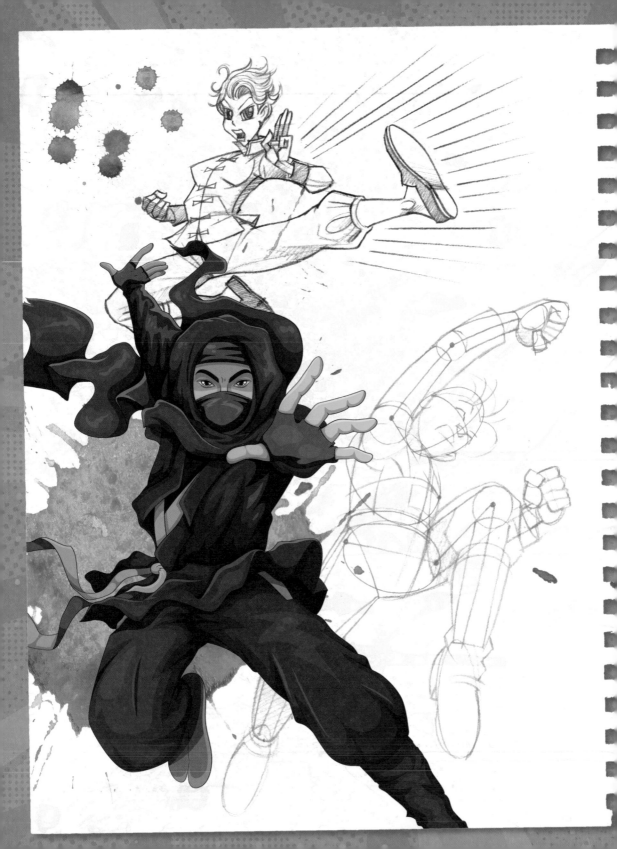

Actions and characters

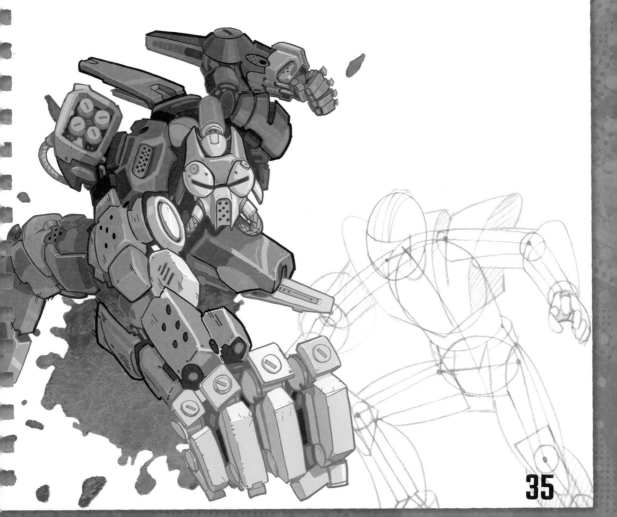

Martial arts

Manga figures are often shown in action, performing martial arts moves.

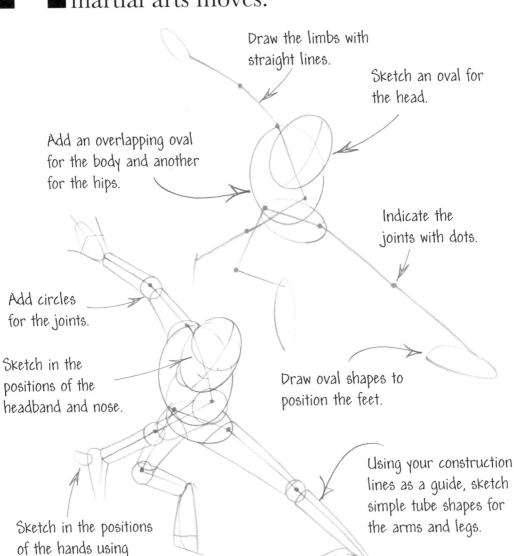

Draw the limbs with straight lines.

Sketch an oval for the head.

Add an overlapping oval for the body and another for the hips.

Indicate the joints with dots.

Add circles for the joints.

Sketch in the positions of the headband and nose.

Draw oval shapes to position the feet.

Using your construction lines as a guide, sketch simple tube shapes for the arms and legs.

Sketch in the positions of the hands using curved shapes.

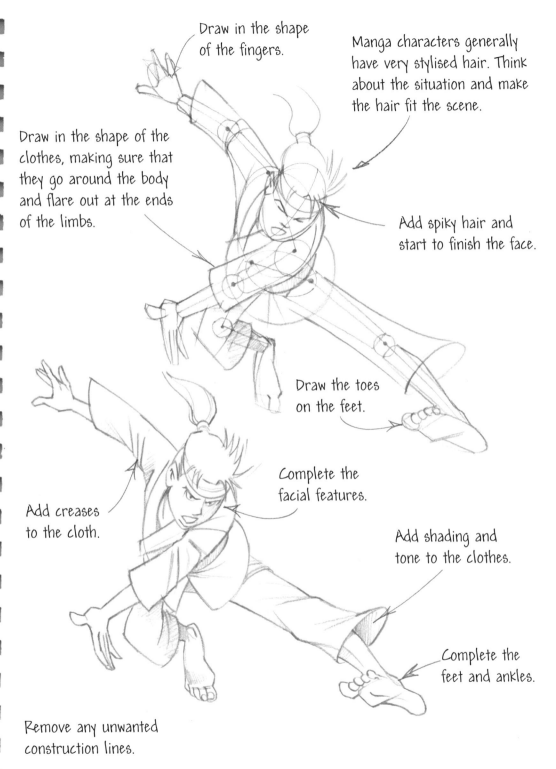

Draw in the shape of the fingers.

Manga characters generally have very stylised hair. Think about the situation and make the hair fit the scene.

Draw in the shape of the clothes, making sure that they go around the body and flare out at the ends of the limbs.

Add spiky hair and start to finish the face.

Draw the toes on the feet.

Complete the facial features.

Add creases to the cloth.

Add shading and tone to the clothes.

Complete the feet and ankles.

Remove any unwanted construction lines.

37

Action kick

This character is jumping in the air and performing a powerful high kick. This pose captures a sense of action and excitement.

Sketch in ovals for the head, body, hips, hands and feet.

Head

Body

Draw two lines to indicate the position and angle of the shoulders and hips.

Hips

Draw straight lines with dots at the joints for the limbs.

Indicate the position of the facial features.

Start to add the shape of the hands.

Fill out the arms and legs using simple tube shapes. The arm furthest away looks smaller and the leg closest looks larger because of the exaggerated perspective.

Outline the shape of the feet.

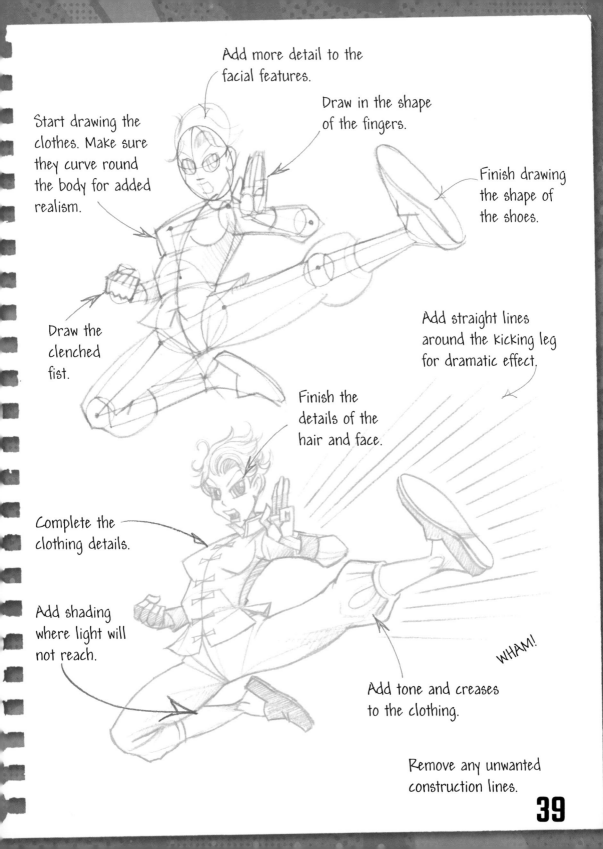

Add more detail to the facial features.

Draw in the shape of the fingers.

Start drawing the clothes. Make sure they curve round the body for added realism.

Finish drawing the shape of the shoes.

Draw the clenched fist.

Add straight lines around the kicking leg for dramatic effect.

Finish the details of the hair and face.

Complete the clothing details.

Add shading where light will not reach.

WHAM!

Add tone and creases to the clothing.

Remove any unwanted construction lines.

39

Jumping fighter

This character has launched himself off the ground and is swinging a punch at the same time.

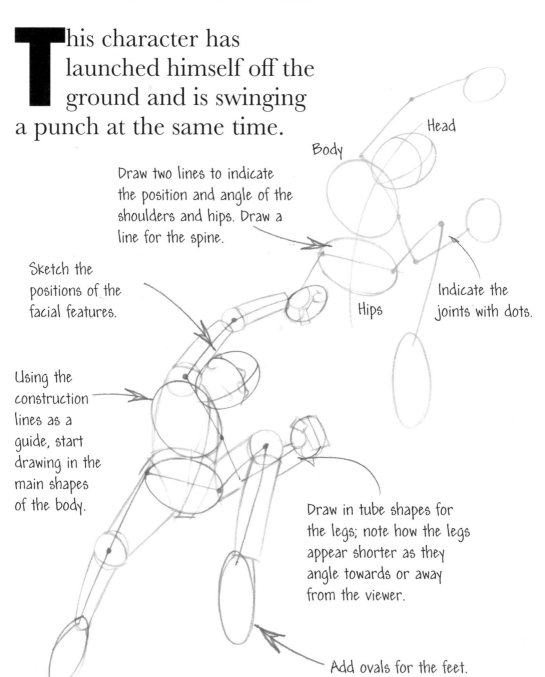

Draw two lines to indicate the position and angle of the shoulders and hips. Draw a line for the spine.

Head

Body

Sketch the positions of the facial features.

Hips

Indicate the joints with dots.

Using the construction lines as a guide, start drawing in the main shapes of the body.

Draw in tube shapes for the legs; note how the legs appear shorter as they angle towards or away from the viewer.

Add ovals for the feet.

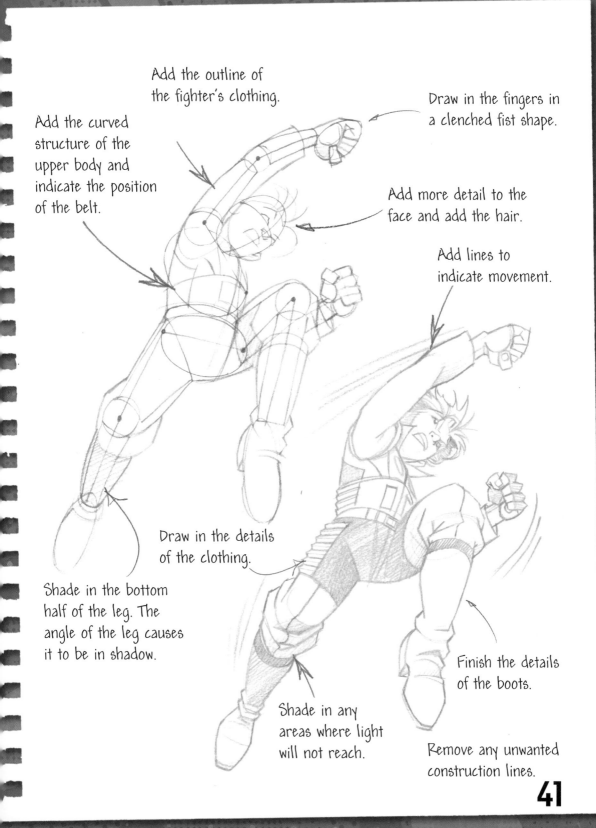

Add the outline of the fighter's clothing.

Draw in the fingers in a clenched fist shape.

Add the curved structure of the upper body and indicate the position of the belt.

Add more detail to the face and add the hair.

Add lines to indicate movement.

Draw in the details of the clothing.

Shade in the bottom half of the leg. The angle of the leg causes it to be in shadow.

Finish the details of the boots.

Shade in any areas where light will not reach.

Remove any unwanted construction lines.

41

Fighting action

These two figures are in the middle of a fight. One of them is being thrown through the air by a swinging punch.

Draw ovals for the body, head and hips. Add straight lines for the limbs.

Head

Body

Hips

Draw dots on the joints.

Draw overlapping ovals for the body and hips.

Draw simple tube shapes for the arms and legs.

Mark the position of the ear.

Draw rounded shapes for the hands and feet.

Draw in the shapes of the body, using your construction lines as a guide.

Draw circles for joints.

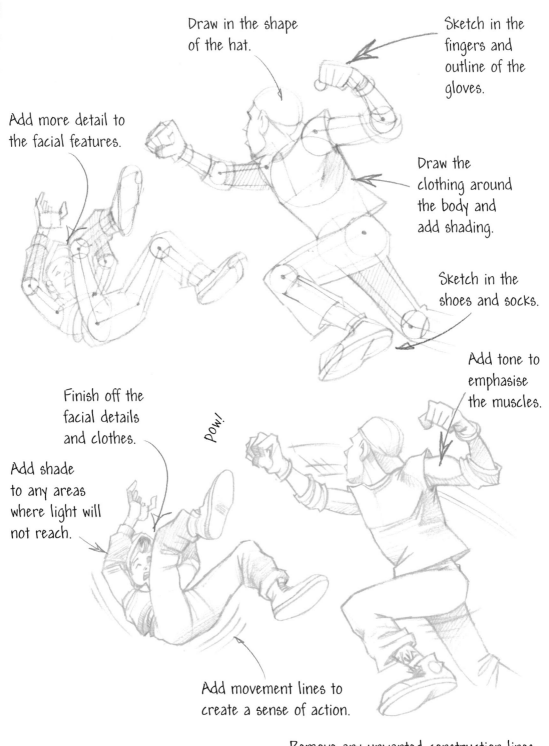

Draw in the shape of the hat.

Sketch in the fingers and outline of the gloves.

Add more detail to the facial features.

Draw the clothing around the body and add shading.

Sketch in the shoes and socks.

Add tone to emphasise the muscles.

Finish off the facial details and clothes.

Pow!

Add shade to any areas where light will not reach.

Add movement lines to create a sense of action.

Remove any unwanted construction lines.

Falling in a fight

It can be hard to keep your balance in the middle of a battle. This character is about to topple over and has a pained expression on his face.

Head

Body

Sketch an oval for the head.

Add an oval for the body and another for the hips.

Indicate the joints with dots.

Add fingers

Draw two lines to indicate the position and angle of the shoulders and hips.

Sketch in the position of the facial features.

Draw the limbs with straight lines.

Add circles for joints.

Draw in the main shape of the body, using the ovals to guide you.

Draw triangle shapes to position the feet.

Using your construction lines as a guide, sketch simple tube shapes for the arms and legs.

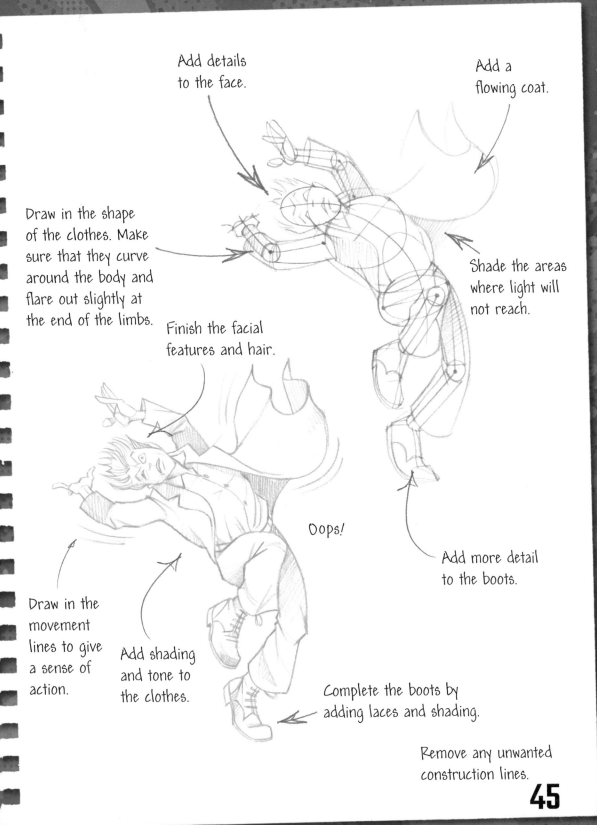

Add details to the face.

Add a flowing coat.

Draw in the shape of the clothes. Make sure that they curve around the body and flare out slightly at the end of the limbs.

Shade the areas where light will not reach.

Finish the facial features and hair.

Oops!

Add more detail to the boots.

Draw in the movement lines to give a sense of action.

Add shading and tone to the clothes.

Complete the boots by adding laces and shading.

Remove any unwanted construction lines.

45

Explosive action

This character has been thrown through the air by an explosion. This pose captures a sense of action and excitement. Will he survive?

Hands

Arms

Body

Hips

Draw straight lines with dots at the joints for each of the limbs.

Start to add the shape of the hand.

Indicate the position of the facial features.

Feet

Legs

Draw lines to indicate the position and angle of the shoulders and hips.

Draw in the shape of the arms using simple tubes. The construction lines will help you to position the limbs and joints correctly.

Add more detail to the shape of the feet.

Add the shape of the legs using simple tubes. The legs are different sizes due to exaggerated pose and perspective.

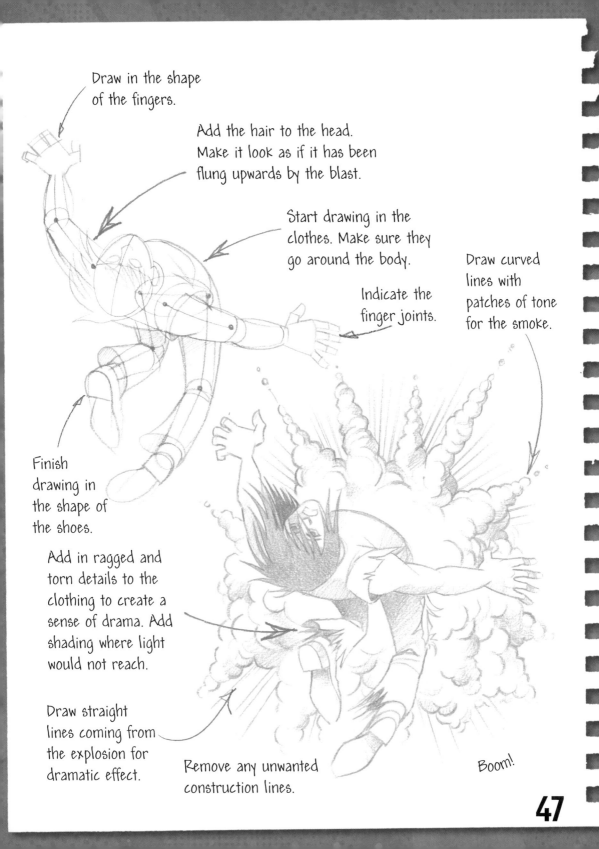

Draw in the shape of the fingers.

Add the hair to the head. Make it look as if it has been flung upwards by the blast.

Start drawing in the clothes. Make sure they go around the body.

Indicate the finger joints.

Draw curved lines with patches of tone for the smoke.

Finish drawing in the shape of the shoes.

Add in ragged and torn details to the clothing to create a sense of drama. Add shading where light would not reach.

Draw straight lines coming from the explosion for dramatic effect.

Remove any unwanted construction lines.

Boom!

47

Vampire fight

Fighting for his life, this manga hero is tackling a vicious vampire. The expressions on their faces should show how they feel during this battle.

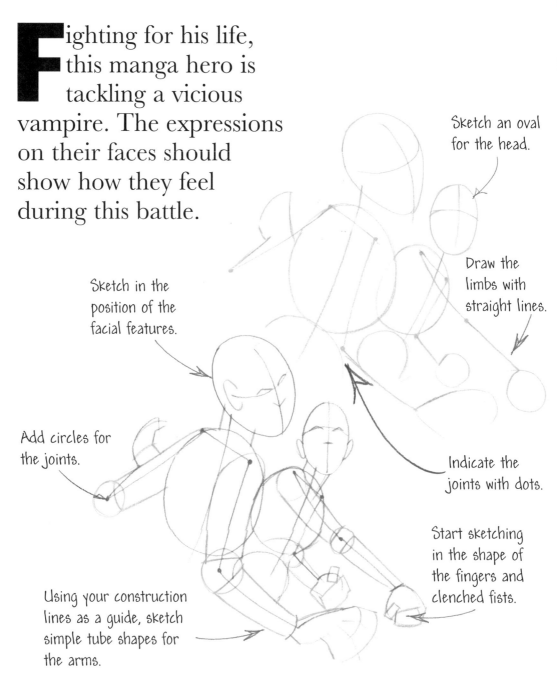

Sketch an oval for the head.

Draw the limbs with straight lines.

Sketch in the position of the facial features.

Add circles for the joints.

Indicate the joints with dots.

Start sketching in the shape of the fingers and clenched fists.

Using your construction lines as a guide, sketch simple tube shapes for the arms.

48

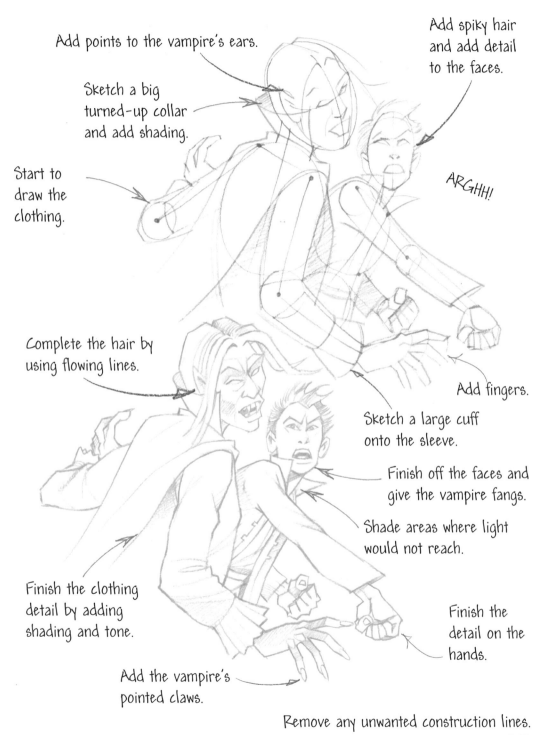

Add points to the vampire's ears.

Add spiky hair and add detail to the faces.

Sketch a big turned-up collar and add shading.

Start to draw the clothing.

ARGHH!

Complete the hair by using flowing lines.

Add fingers.

Sketch a large cuff onto the sleeve.

Finish off the faces and give the vampire fangs.

Shade areas where light would not reach.

Finish the clothing detail by adding shading and tone.

Finish the detail on the hands.

Add the vampire's pointed claws.

Remove any unwanted construction lines.

49

Warrior

Rushing into battle, this warrior is wielding a club as his weapon. His action pose and sense of movement create a dynamic drawing.

Draw in different sized ovals for the head, body, hands and hips.

Draw limbs with straight lines.

Only draw one line for this leg because only the thigh is visible in this pose.

Sketch in the club.

Using the construction lines as a guide, start drawing the main shapes of the body.

Indicate the joints with dots.

Draw in circles for joints.

Draw in tube shapes for the legs; remember, the pose will affect the leg length.

Draw in square shapes for the clenched fists.

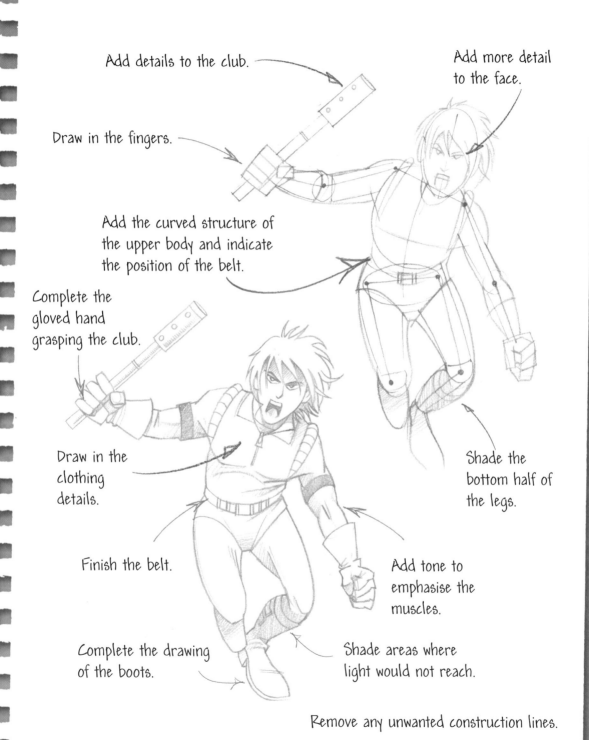

Add details to the club.

Add more detail to the face.

Draw in the fingers.

Add the curved structure of the upper body and indicate the position of the belt.

Complete the gloved hand grasping the club.

Draw in the clothing details.

Shade the bottom half of the legs.

Finish the belt.

Add tone to emphasise the muscles.

Complete the drawing of the boots.

Shade areas where light would not reach.

Remove any unwanted construction lines.

Samurai

The samurai warrior stands defiant, sword drawn and ready for battle.

Now start to build up the basic features of your figure.

Draw the main shape of the body, using the ovals to guide you.

Draw in simple tube shapes for the arms and legs.

Draw an oval for the body and smaller ovals for the hands.

Indicate the length and direction of the sword.

Head

Body

Hand

Feet

Draw an oval for the head.

Draw two lines to indicate the position and the angle of the shoulders and hips. Draw in a line for the spine.

Sketch in simple shapes for feet.

Sketch in the arms and legs using straight lines. Add dots to indicate the joints.

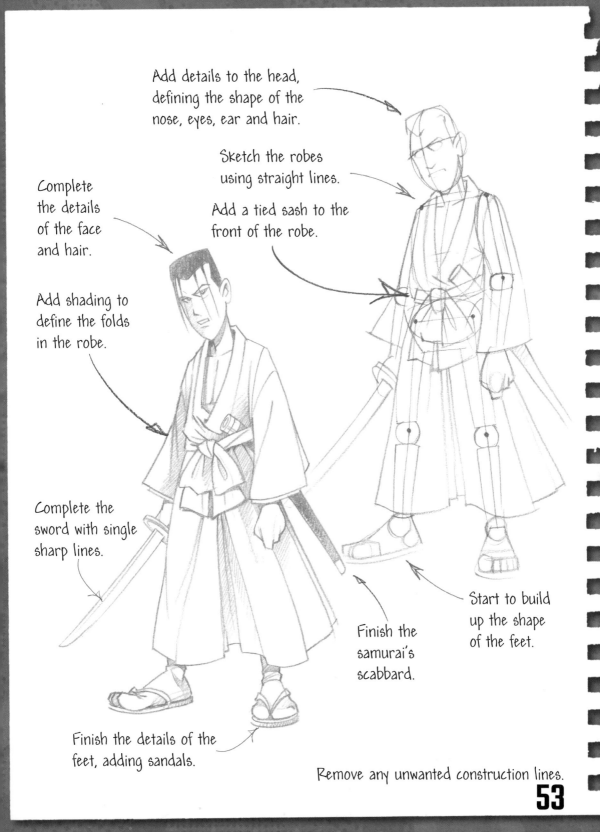

Add details to the head, defining the shape of the nose, eyes, ear and hair.

Sketch the robes using straight lines.

Add a tied sash to the front of the robe.

Complete the details of the face and hair.

Add shading to define the folds in the robe.

Complete the sword with single sharp lines.

Finish the samurai's scabbard.

Start to build up the shape of the feet.

Finish the details of the feet, adding sandals.

Remove any unwanted construction lines.

Defensive girl

This manga fighting girl is in the middle of a fight and has adopted a defensive pose. She is careful to protect her face whilst still being ready to attack.

Draw in different sized ovals for the head, body and hips.

Head

Body

Hips

Sketch the positions of the facial features.

Draw in shapes for clenched fists.

Draw limbs with straight lines.

Indicate the joints with dots.

Using the construction lines as a guide, start drawing in the main shapes of the body.

Draw in circles for the joints.

Add more detail to the shape of the feet.

Draw in tube shapes for the legs.

Sketch the flowing hair.

Add more detail to the face.

Draw in the fists.

Draw the curved structure of the upper body and indicate the position of the belt.

Finish the details of the hair and the face.

Add in the trouser details.

Finish the belt.

Draw in the clothing details.

Add tone to the clothing by shading.

Shade areas where light would not reach.

Remove any unwanted construction lines.

55

Mecha giant robot

This humanoid robot is poised and ready to go into battle.

Draw two lines to indicate the position and angle of the shoulders and hips. Draw in a line for the spine.

Draw different sized ovals for the head, body and hips.

Head

Draw simple lines for the limbs, adding dots for the joints.

Body

Sketch in the shapes of the arms and legs. Add circles to indicate the elbows and knees.

Hips

Sketch oval shapes for the hands.

Start sketching in the mechanical fingers.

Draw rounded shapes for the robot's feet.

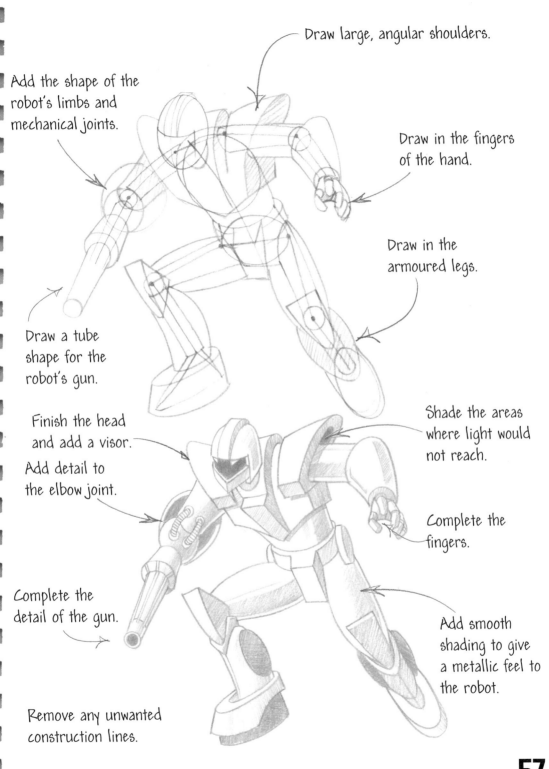

Draw large, angular shoulders.

Add the shape of the robot's limbs and mechanical joints.

Draw in the fingers of the hand.

Draw in the armoured legs.

Draw a tube shape for the robot's gun.

Shade the areas where light would not reach.

Finish the head and add a visor.

Add detail to the elbow joint.

Complete the fingers.

Complete the detail of the gun.

Add smooth shading to give a metallic feel to the robot.

Remove any unwanted construction lines.

57

Robot

This robot is built in a humanoid form and is ready to perform whatever task is set.

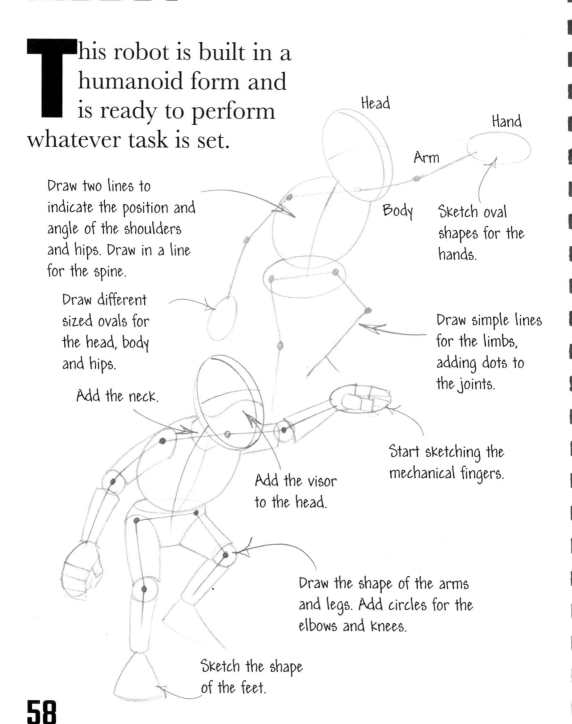

Head

Hand

Arm

Body

Draw two lines to indicate the position and angle of the shoulders and hips. Draw in a line for the spine.

Sketch oval shapes for the hands.

Draw different sized ovals for the head, body and hips.

Draw simple lines for the limbs, adding dots to the joints.

Add the neck.

Start sketching the mechanical fingers.

Add the visor to the head.

Draw the shape of the arms and legs. Add circles for the elbows and knees.

Sketch the shape of the feet.

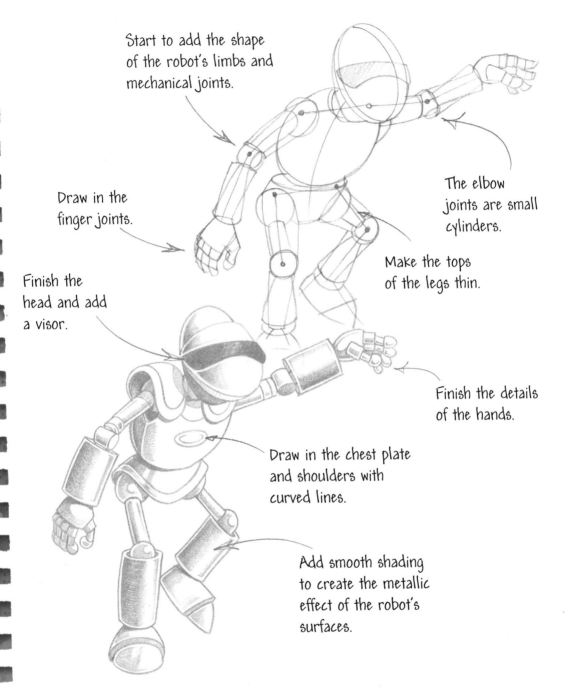

Start to add the shape of the robot's limbs and mechanical joints.

Draw in the finger joints.

The elbow joints are small cylinders.

Make the tops of the legs thin.

Finish the head and add a visor.

Finish the details of the hands.

Draw in the chest plate and shoulders with curved lines.

Add smooth shading to create the metallic effect of the robot's surfaces.

Remove any unwanted construction lines.

Glossary

Construction lines Guidelines used in the early stages of a drawing which are usually erased later.

Cross-hatching A series of criss-crossing lines used to add shade to a drawing.

Gouache Paint made with pigment, water and a glue-like substance.

Hatching A series of parallel lines that are used to add shade to a drawing.

Manga A Japanese word for 'comic' or 'cartoon'; also the style of drawing that is used in Japanese comics.

Martial arts Traditional systems of combat, typically used for self-defence.

Mecha Genres of science fiction storytelling and art that focus on giant robots controlled by people.

Parallel When two or more things are placed side by side and have the same distance between them.

Perspective The technique of depicting a three-dimensional object in a two-dimensional picture by making sure that each part of the object is in the correct position in relation to the others and the position of the viewer.

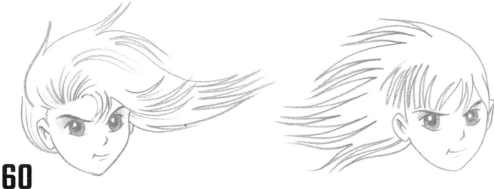

Proportions The size of each part of something in relation to the whole.

Samurai The military nobility of medieval and early-modern Japan.

Sash A large band of coloured ribbon worn around the body, typically the waist.

Scabbard A sheath for holding a sword or other kind of blade.

Silhouette A drawing that shows only a dark shape, like a shadow, sometimes with a few details left white.

Tone The contrast between light and shade that helps to add depth to a picture.

Vampires A mythical species of blood-drinking, undead monster found in many different cultures worldwide.

Vanishing point The place in a perspective drawing where parallel lines appear to meet.

Index

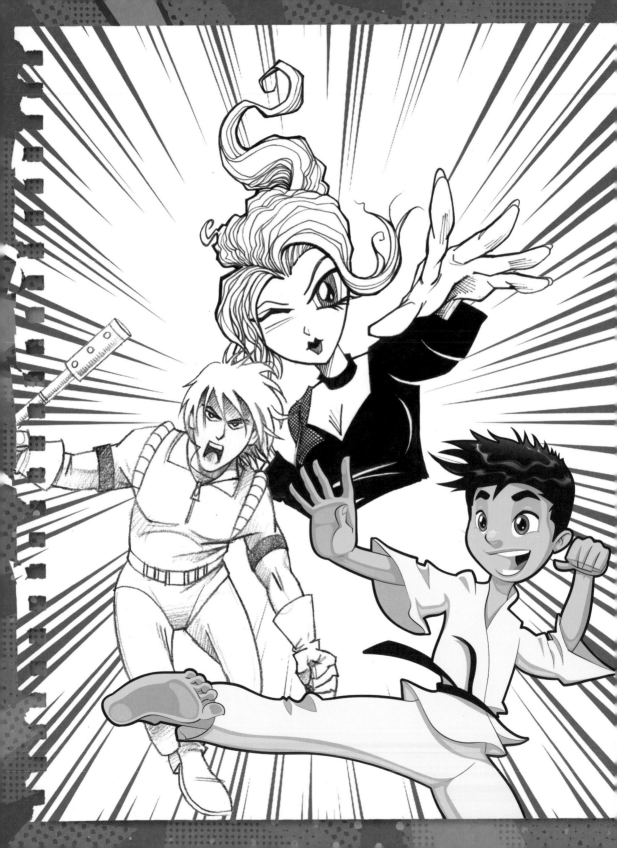